winter in europe

"I don't know where I'm going, but I'm on my way" ...

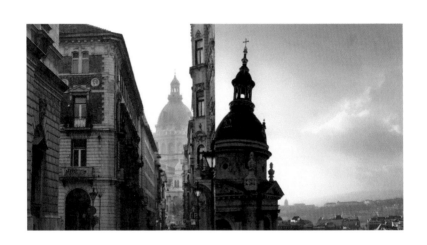

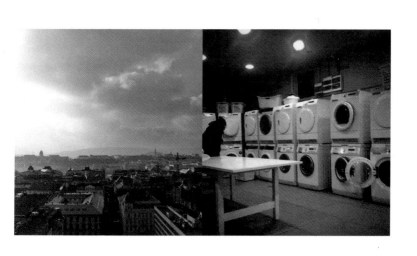

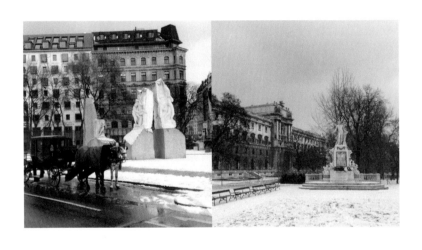

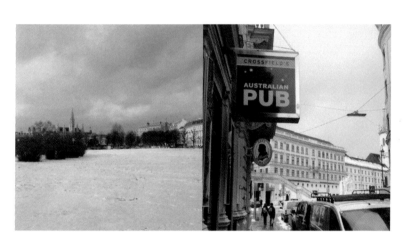

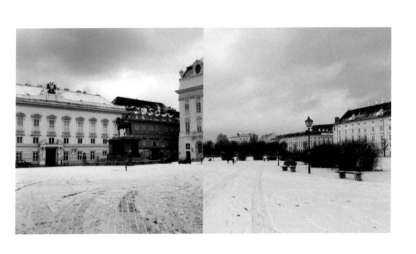

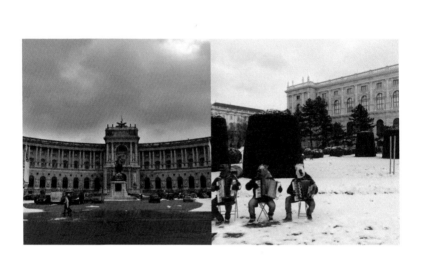

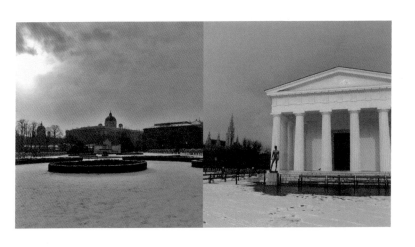

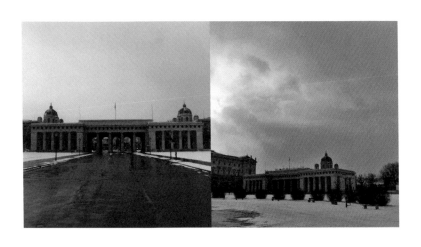

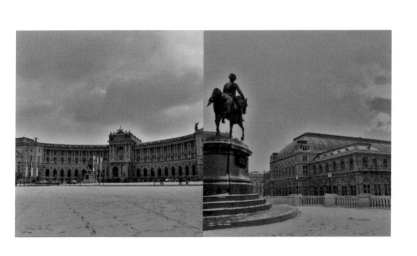

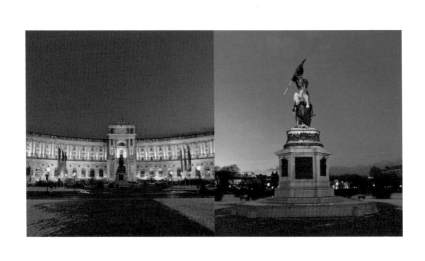

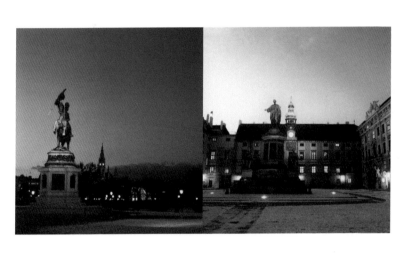

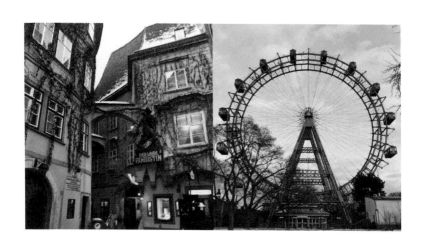

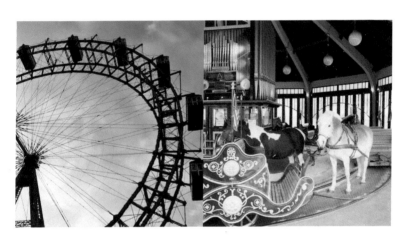

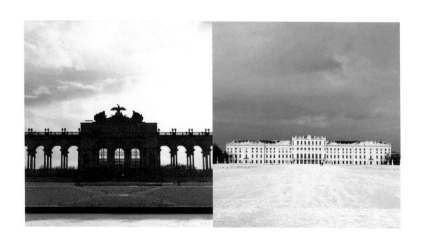

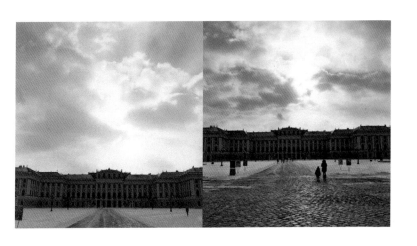

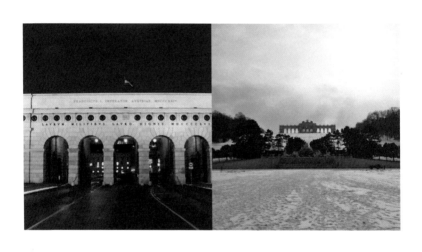

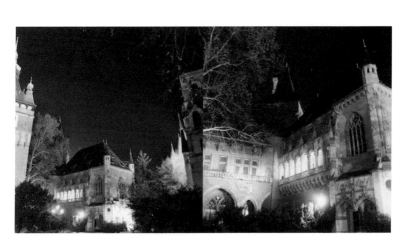

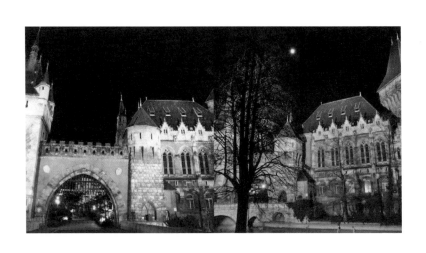

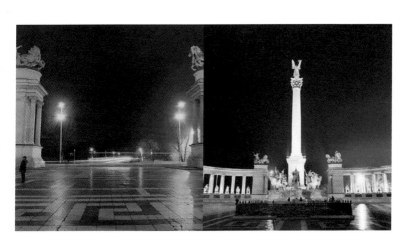

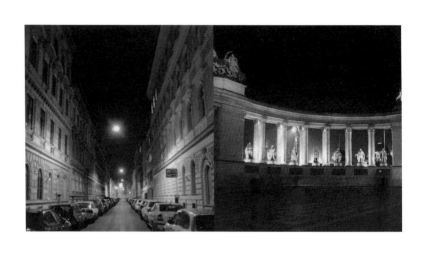

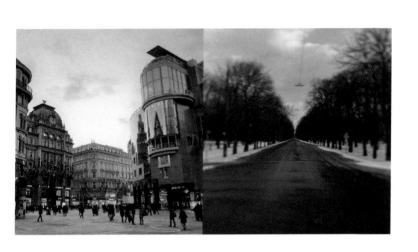

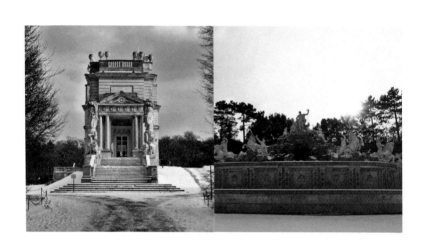

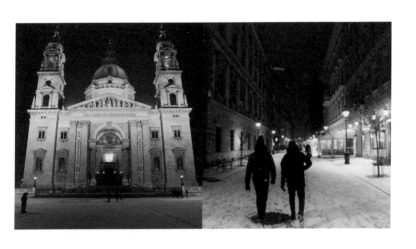

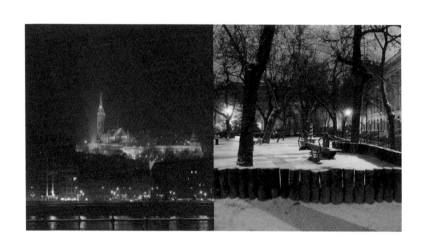

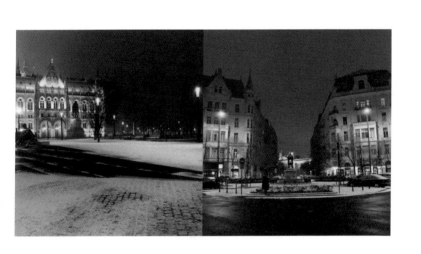

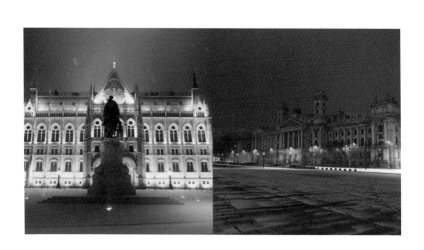

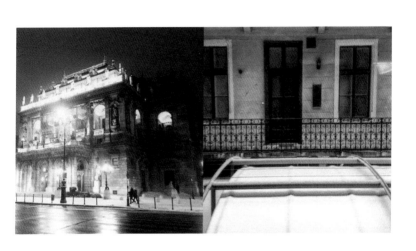

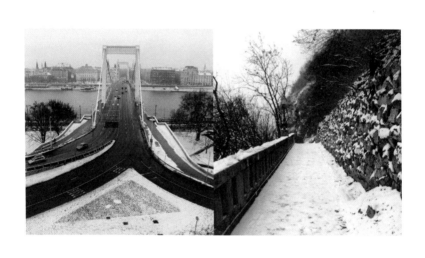

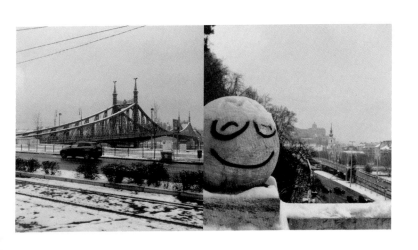

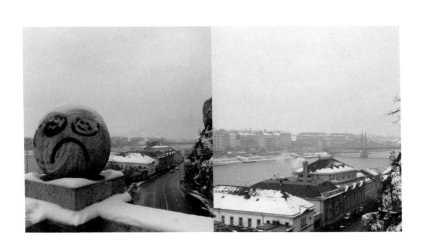

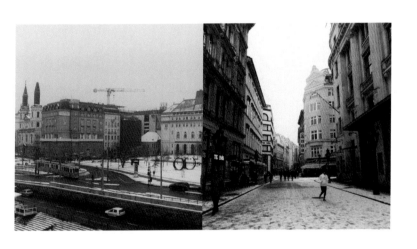

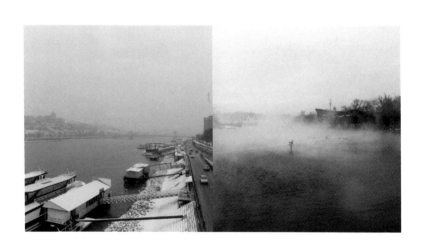

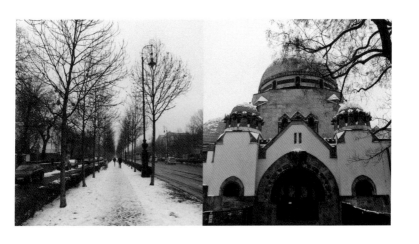

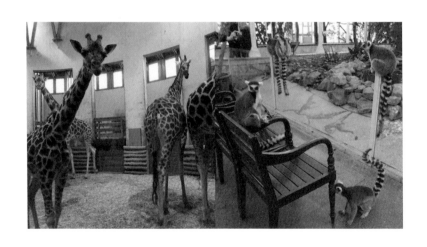

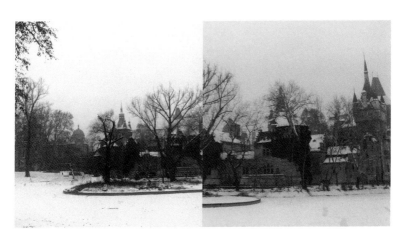

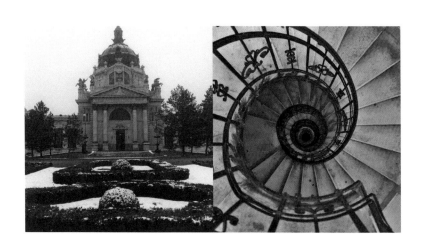

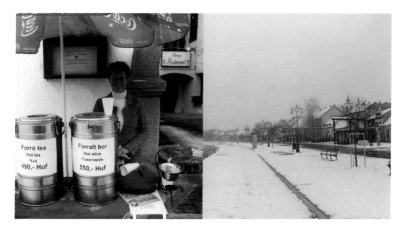

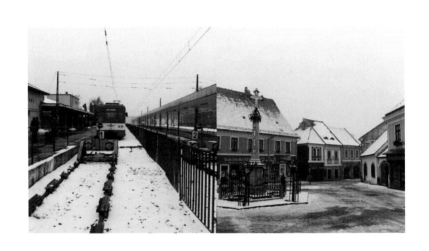

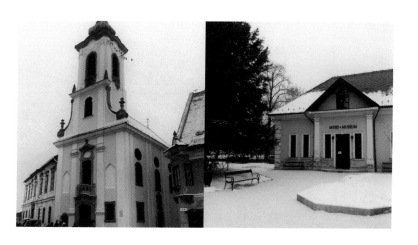

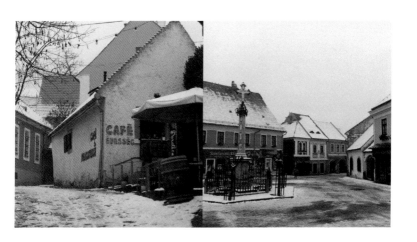

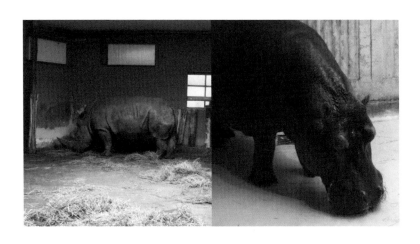

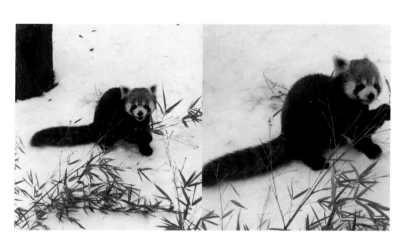

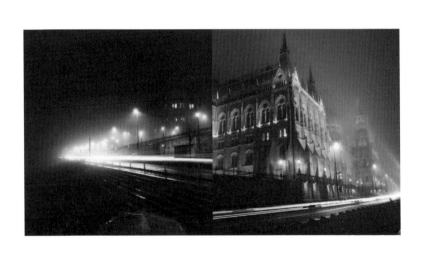

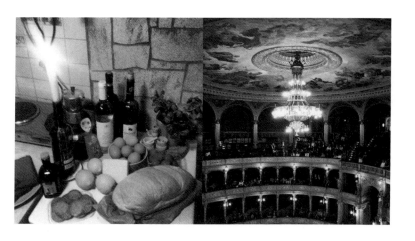

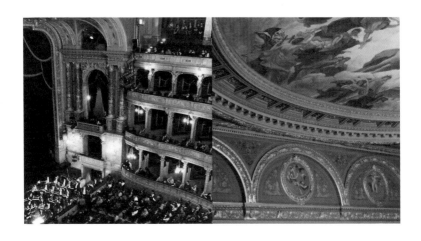

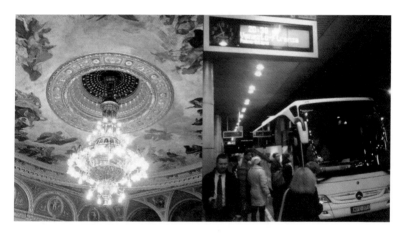

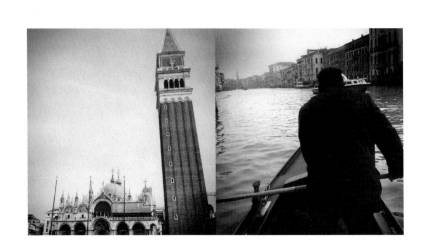

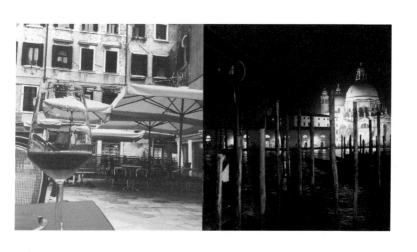

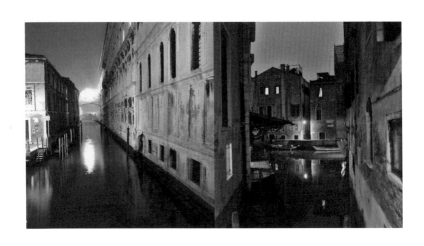

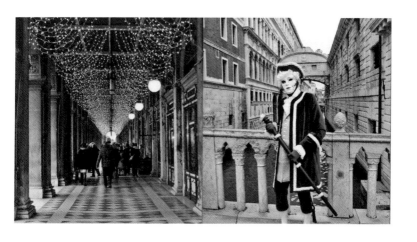

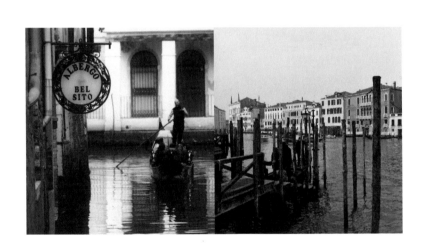

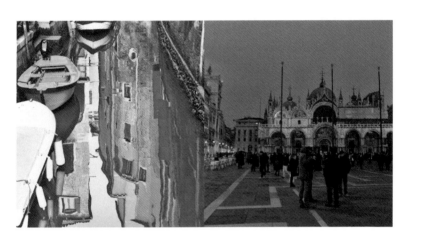

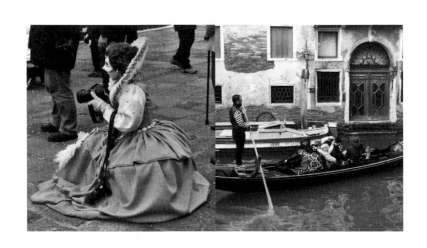

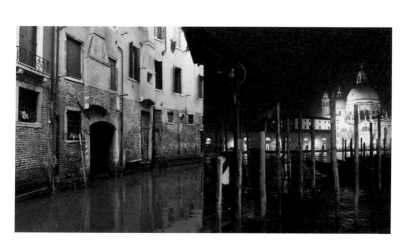

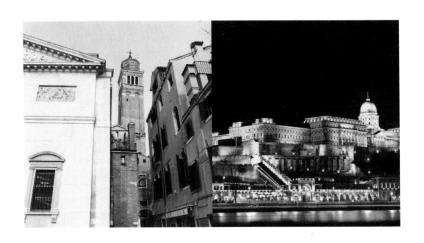

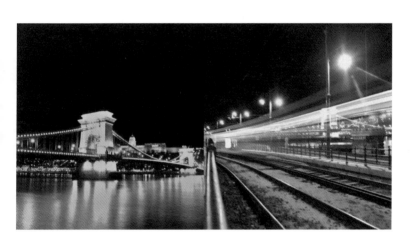

CPSIA information can be obtained at www.ICGtesting.com
Printed in the USA
BVIW121202020919
557354BV00012B/101

* 9 7 8 0 4 6 4 1 8 9 4 2 8 *